STUDY GUIDE

Theresa Ann Valentino

Condordia University

ART HISTORY

SECOND EDITION

VOLUME TWO

MARILYN STOKSTAD

PRENTICE HALL, UPPER SADDLE RIVER, NEW JERSEY 07458

©2002 by PEARSON EDUCATION, INC.
Upper Saddle River, New Jersey 07458

10 9 8 7 6 5 4 3

ISBN 0-13-091866-0

Printed in the United States of America

Table of Contents

Chapter 17

Early Renaissance Art in Europe

Stokstad aligns the Renaissance closely with the ideas of Humanism. The text also describes the Renaissance as being rooted in several places throughout Europe at the turn of the fifteenth century. Your objective will be to try to connect the ideas of humanism and the Renaissance occurring in these different locals as you work through this chapter. By the time you finish this chapter in the workbook, you should have a clear understanding of the following concepts and be able to answer these questions with ease.

1. **How does the human figure transform during the Renaissance? How would you describe these changes?**

2. **What new kind of portrait appears during the early Renaissance?**

3. **What new techniques in painting and printmaking become significant during the Renaissance?**

4. **What is linear perspective? What is atmospheric perspective? How do these scientific conventions change the art of the Renaissance?**

5. **Can you connect the developments of these different countries: France, Flanders, Spain and Portugal, Germany, and Italy, during the Renaissance?**

Humanism and the Renaissance

Vocabulary

Renaissance	patronage	Middle Ages
Netherlands	poet laueate	aristocracy
dark ages	scholasticism	Summa theological
vernacular	typology	tableaux vivants
register	Eucharist	alterpiece
volumetric	Protestant Reformation	pictorial space
piazza	linear perspective	rendering

Fill in the Blanks

1. Unlike the hereditary aristocracy that had dominated society during the Middle Ages, these _____ and _____ had attained their place in the world through personal achievement.

2. In its traditional usage, _____, a nineteenth century term, is used narrouly for the revival of classical learning and literature.

3. For all our differences, we still live in a Petrarch's modern period --- a time when_____ _____, their deeds, and their beliefs have primary importance.

4. Especially important to the Renaissance was the conjunction of _____ and _____ that was addressed by scholasticism in the twelfth century and was explicated by Thomas Aquinas in the Summa theological of 1267-1273.

Short Essay

1. There is much discussion in your text about the ideal city. What is the ideal city?

2. Was the emphasis for this ideal city placed on economy, military fortification, spirituality or something else?

3. What is meant by humanism? Your text refers to the humanist ideal was this ideal ever achieved? Please explain why or why not?

French Court Art at the turn of the century

Vocabulary

manuscripts

Illumination

apprenticeships

guilds

Tres Riches Heures

Chartreuse

illustration

herbals

Noblewomen

Flemish

provenance

Short Essay

1. What types of manuscripts were popular among the French nobility?

2. How did the painters of Holland and Flanders impact French manuscript illumination?

3. How did the Limbourgs portray the laboring classes in their illuminations?

4. What International Gothic conventions are displayed in the Paul Herman and Jean Limbourg, Page with *February, Tres Riches Heures*?

5. What is the Book of Hours?

Long Essay

What role were women allowed to play in the arts during the late medieval and Renaissance periods?

Flemish Art

Vocabulary

Flanders	Bruges	patron
Guild	Guild of St. Luke	Civic Group
panels	Burgundy	exponents
Master of Flemalle	majolica	symbolism
gesso	picture plane	Incarnation
spatial conventions	tempera	glazing
canvas	atmospheric perspective	Als ich chan
triptych	gilded	polyptych
idealization	diptych	tapestry
cope	A ma vie	glazes

Fill in the Blanks

1. Artist work _____ in their own studios without the _____ of an influential patron, but they had to belong to a _____ _____.

2. In the fourteenth century artists painted on _____ _____, designed tapestries and stained glass, and illuminated manuscripts.

3. By the fifteenth century _____ had become the leading medium.

Short Essay

1. Describe the financial disposition of Belguim (this part of the southern Netherlands was known as Flanders) in the fifteenth century? What was the economy dependant on?

2. How were the guilds prevalent in Flanders? Were painters members of these guilds?

3. What is the interpretation of Robert Campin's Merode Alterpiece? Is their a deeper narrative with in the painting? Describe the symbolic representation hidden within the images of this work?

4. Jan van Eyck used oil paint in his paintings and applied this paint in a series of layers referred to as glazes. Why did this kind of painting become so popular?

5. Name a work where Jan van Eyck uses the convention of atmospheric perspective?

6. The Portrait of Giovanni Arnolfini and His Wife, Giovanni Cenami is often thought to be a portrait of their wedding, why is this the customary interpretation?

7. Describe the figures in the Ghent Altarpiece? Who are these figures in real life and is it customary for them to be painted in this fashion? You have seen the terms, diptych, triptych and polyptych in your vocabulary list does this work apply to any of these terms and if so which one?

8. Has Jan van Eyck ever painted a self portrait?

9. Who is Rogier van der Weyden?

10. Do art historians assign works to him, when he did not sign his name to these paintings and if so how do they decide which paintings are his?

11. In the work, Deposition, a popular scene was portrayed which often was used in feast days as a *tableau vivant*, what was the scene and how does the gilding work with the figures to add emotion to this scene?

Long Essay

1. Describe the difference between first and second generation painters in Flanders? Give examples of art and artists.

2. Painting on wood panels became the medium of choice during the fifteenth century, outweighing the popularity of tapestries, stained glass and manuscript illumination. Describe the technique of painting on wood panels?

3. Given the symbolic meanings found in many of these paintings describe in detail Hugo van der Goes Portinari Altarpiece. Who are saints and what symbolism do they portray? What about the still life images?

The Spread of Flemish Art in Europe
Portugal, Spain, French & German Art

Vocabulary

courtiers	Hispano-Flemish	virtuoso
Joan of Arc	houppelande	blasphemous
pilasters	martyr	focal point
allegory	amour	International Gothic Style
plague	typographical portrayal	refraction

Short Essay

1. How did Flemish spread through Europe (be sure to include Spain, Portugal, Germany, and France)?

2. What court artist painted portraits of Charles VII, Etienne Chevalier and Saint Stephen in fifteenth century France? This artist was influenced by Flemish painting describe in what ways this is evident from the works in your text.

3. In Nuno Goncalvez's Saint Vincent with the Portugese Royal Family, an event is being celebrated, what event is it? How is this artist influenced by Flemish painting?

4. Your text reveals research which leads to a possible relative of Jan van Eyck as the court painter for Rene the duke of Anjou. Clarify this conclusion. Who was the relative?

The Italian Renaissance in Florence

Vocabulary

Florence
carnal
Classical antiquity
dome
drum
vault
centering
nave
basilica
impost block
bay
Lorenzo Ghiberti
high relief
middleground
single point perspective
Paolo Uccello
fresco
trompe l'oeil
Masaccio
Fra Angelico
Fra Girolamo Savonarola

Pisa
Neoplatonism
Secular
Donatello
arch
oculus
course
transept
clerestory
capital
cornice
treatise
low relief
background
Della Pittura
equestrian
mural
coffers
cartoons
Sandro Botticelli

Medici
Neoplatonic
illusion
Brunelleschi
rib
lantern
sacristy
crossing
Corinthian
lunettes
architraves
Florence Baptistry
foreground
vanishing point
Leon Battista Alberti
terra-cotta
aedicule
Crucifixion
sinopia
mythological

Short Essay

1. How did Sandro Botticelli reflect ideas on the subject of humanism in his paintings?

2. Describe how the "Tribute Money" works with light to create a more realistic illusion?

3. How did Donatello's work change at the end of his career? Describe those changes.

4. Describe how Brunelleschi used architectural elements to design the dome for the Florence Cathedral? What elements did he use? Below is an image of this design label each element.

5. What is linear perspective? Contrast and compare intuitive perspective and linear perspective. Pick any two examples from your book (such as Masaccio's Trinity with the Virgin, Saint John the Evangelist and Donors with the Merode Altarpiece for example by Robert Campin) to describe the differences.

Matching

Donatello
Ghiberti
Masaccio
Fra Angelico
Sandro Botticelli
Fra Girolamo Savonarola

A. The statue of David which was first recorded as having resided in the courtyard of the Medici palace was created by _____.

B. _____short career reached its height during the collaboration with a painter by the name of Masolino.

C. Born Guido di Pietro, this artist was nicked named by his friends as _____ and was known for his pious nature.

D. Working under the tutelage of Verrochio and Pollaiuolo, _____looked to examples of ancient art rather than just the humanist philosophy and speculation of classical thinking.

E. _____ a Dominican monk preached against the wordly images and ideas that were prevalent in Florence during this period.

F. The "Tribute Money is _____'s most celebrated painting due to the integration of figures, architecture and landscape into a consistent narrative event.

Long Essay

Describe in detail the difference in International Gothic style and the use of linear perspective in the Early Renaissance. Use several artists work to defend your position. Use the integration of figures, architecture and landscape in the Tribute Money as one of your examples.

The Italian Renaissance outside of Florence

Terminology

Latin-cross plan	façade	piers
Central-plan churches	martyrium	tholos
veneer	palazzo ducale	composite capital
volutes	foreshortening	Padua
Pisa	Milan	Piero della Francesca
Venice	Urbino	Andrea Mantegna
radical perspective	balustrade	putti
seraphim	stigmata	intarsia
medallion	Gentile Bellini	Giovanni Bellini

Short Essay

1. How does Giovanni Bellini demonstrate a new investigation of nature? Which of his works describe this investigation?

2. Describe how Leon Battista Alberti's architectural design for the Church of Saint Andrea is influenced by classical architecture. Which classical elements of architecture are used in this design?

Long Essay

If you were an artist in the Early Renaissance, what technique or combination of techniques would you use to paint images that would seem a great distance away from the viewers. Describe your techniques in detail.

European Printmaking and Bookmaking

Terminology

engraving	intaglio	edition
watercolor	burins	block books
movable-type printing	Johann Gutenberg	woodcuts

Short Essay

1. What process did Johann Gutenberg invent which changed the spiritual and intellectual growth of Europe? Describe how this process worked.

2. What methods of book illustration were prevalent during the late fifteenth century? How were these images used to save time and money?

Chapter 18

Renaissance Art in Sixteenth Century Europe

Art and society witnessed an explosion of curiosity and inquiry that begins in the fifteenth century and continues in the sixteenth century. This explosion is referred to as the **High Renaissance**. Artists who you may be familiar with from this era are Leonardo da Vinci, Michelangelo, and Dürer, to name just a few. During this period there is a major religious crisis, known as **The Reformation**. The events of The Reformation revised the geography in addition to the religion of Europe. Theological turmoil was coupled with scientific upheaval, and global exploration. The art of this time period plays an important part in the historical episodes and as a result enlightened people with an understanding of the magnificent changes taking place. After you have finished this chapter in your workbook, you should have a clear understanding of the following concepts. Read these questions now and think about them throughout your work then respond to them at the end of the chapter:

1. **What was the social status of the artist?**

2. **What did notable figures of the High Renaissance share? What differentiated them from each another?**

3. **What artistic progression led to identifying the beginning of the sixteenth century in Italy as the "High Renaissance."**

4. **What are distinguishing characteristics of the High Renaissance, as opposed to "Mannerism."**

5. **Did other countries adopt and individualize styles of the High Renaissance?**

6. **How did The Reformation change the artistic, political and religious face of Europe?**

Italian Art

Vocabulary

Veronese
Raphael
Sansovino
art restoration
Vitruvian man
Titian
Palladio
Theologians
facade
pilasters
moldings
quoins
engaged columns
Vignola
contrapposto
Pieta
Jesuit order
bucranium

Vinci
Correggio
Leone Leoni
intonaco
Vatican
Veronese
Reformation
peristyle
rusticated
entablature
motifs
loggia
hemicycles
sfumato
Disputa
spandrels
Latin cross plan
prophet

Leonardo da Vinci
Michelangelo
pope
Bramante
Giorgione
Tintoretto
papacy
balustrade
cartouche
stringcourses
brackets
engaged half columns
segmental pediments
chiaroscuro
dado
Lorenzo the Magnificent
central plan
sibyl

Matching

Leonardo da Vinci
Michelangelo
Raphael
Donato Bramante
Vignola

1. Only about a dozen paintings can be attributed to _____, but hundreds of drawings still exist. His notebooks indicate his skill as an architect, engineer, designer of military weapons and machines (including a helicopter and an airplane).

2. _____designed the dome and cross-shaped structure that now comprises the apse of Saint Peter's Cathedral in Rome.

3. Known for his Madonna images, _____also painted the *School of Athens* which resides in the Stanza della Segnatura, Vatican, Rome.

4. The Rule of Five Orders of Architecture was written by _____.

5. Tempieto ("little temple") recalls an early Christian style of shrine which was built over a sacred area and was designed by the architect _____.

Italian Architecture - Short Essay

1. How did the Renaissance architect Vignola differ from medieval castle builders when it came to building fortified structures?

2. What classical elements appear in Renaissance architecture?

3. Describe why the Tempietto was built where it was.

4. Describe the Renaissance Palace Facade.

5. What is a balustrade?

6. Briefly describe the changing needs of the congregation that ultimately changed the architectural designs of Saint Peter's Basilica from the period of 1506 to1612. Who were the artists involved in this project over this time period?

7. Who is entombed under Saint Peter's Basilica?

8. Did the changing needs of Saint Peter's Basilican congregation reflect a political disposition of the Vatican and if so what position did it reflect?

Italian Painting - Short Essay

1. How did Leonardo experiment with technique on his famous painting of *The Last Supper*? Describe his use of one point perspective in this work and be sure to list the position of the figures as well its placement with in the space it was painted?

2. What was the debate between Michelangelo and Leonardo concerning the importance of painting and sculpture? Who won?

3. What was the social status of the artist during the High Renaissance? How did the above debate reflect the changing social status of the artist during this time? How are artists looked at today?

4. Michelangelo did a portrait of himself in the Sistine Chapel. What is the name of the composition where his portrayal is and how did he depict himself in this visual rendering?

5. How does Raphael's *School of Athens* portray the complete absorption of humanism and science within the Vatican?

6. Who is Antonio Allegri? Who were his influences?

7. Only four or five paintings have been accepted by the academic world as being attributed to Giorgione. One painting is the subject of inquiry still today. Describe this mysterious painting and why art historians are still puzzled by it.

8. Titian studies under the above artist. Describe his work and how he worked with color and brush strokes? What painting of Titian's inspired a multitude of artists as a familiar pose to portray female beauty. This familiar pose is used even now.

9. Who was Isabella d'Este?

Italian Painting – Long Essay

Describe in detail the themes of the Sistine Chapel including the images painted on the ceiling as well as those above the altar. How do these two compositions differ visually? How do they reflect the changes going on in the church? What do you think the messages were that Michelangelo was trying to convey?

Italian Sculpture - Short Essay

1. What inconsistencies are often noted in descriptions of Michelangelo's *Pieta*?

2. Why did Michelangelo go to great lengths to choose his own blocks of stone for his sculptures? Did this reflect any theory he had about creativity or spirituality?

3. Contrast and compare Donatello's David with Michelangelo's David.

4. Who is Leone Leoni? What was unusual about the life size figure of the Emperor Charles V of Spain?

Long Essay

Michelangelo designed a complex sculptural arrangement for the tomb of Guiliano de Medici, describe this setting and elaborate on Michelangelo's meaning behind this composition.

Italian Mannerism

Vocabulary

Maniera	stylistic	distortions
Pontormo	Parmigianino	Bronzino
gestures	obscure	spatial effects
Sofonisba Anguissola	Rosso Fiorentino	Giovanni da Bologna
elongated	juxtapositions	exaggerated
classical orders	Giulio Romano	rationality
contortion	Frederigo Gonzaga	plinth
Lavinia Fontana	stanza	

Short Essay

1. Where did the term Mannerism come from?

2. Did the meaning of the term Mannerism change over time? If so when did it change and how?

3. Describe visual traits and compositions often used by Mannerist artists. Does this reflect a change from the Renaissance artists? How is this work different?

4. What Mannerist strategy does Pontormo use in his painting, *Entombment*? Contrast that with the devices used by Parmigianino. How do these two Mannerist are differ and are these strategies effective?

5. Who is Sofonisba Anquissola? Give the history of where she learned her trade and where she was most successful? Was this a normal occupation for women?

6. What Italian city claimed to have over two dozen female painters? Who was one of the most famous female painters from this area (primarily painting narrative and portraits)?

7. What Mannerist variations did Giulio Romano use on the Palazzo del Te, Mantua?

8. Who commissioned Giovanni da Bologna?

Painting and Architecture in Venice and the Veneto

Vocabulary

Sack of Rome	piazza	bays
Jacopo Robusti	Palladio	commission
Monastery	treatises	villa
Rotunda	spandrel	frieze
putti	garland	

Short Essay

1. Who is Jacopo Robusti? How was his work flattered well after his death?

2. Andrea di Pietro was nicknamed Palladio due to the strong influences of what fourth century writer?

3. What occurred in 1527 that allowed architecture to flourish in other areas of Italy besides Florence and Rome?

The French Court

Vocabulary

Francis I	portraitist	Primaticcio
Chateaux	School of Fountainbleau	Jean Goujon
Pierre Lescot	turrets	stucco sculpture
architectonic	Italianate decoration	Philibert de l'Orme
Benvenuto Cellini	enamel	Bernard Palissy

Short Essay

1. What was the name given to the rural palaces of France?

2. What was the first big project of Primaticcio's involving Anne, the duchess of Etampes? Was this project given a stylistic name and if so what was that name and why do you think it was called this?

3. These two artists worked together (an architect and a sculptor) to design the west wing of the Louvre. Who were they and how did this collaboration manifest into a new way of thinking about sculpture? What elements did they coordinate?

4. This French craft artist was appointed "inventor of rustic figurines." Who was this artist and what types of materials did he use?

Spain and the Spanish Court

Vocabulary

Philip II

El Escorial

El Greco

Ignatius Loyola

Orgaz family

topographical

Islam

Bramantean

Byzantine

Teresa of Avila

spatial

Jesuit order

Spanish Armada

Juan Bautista de Toldea

Domenikos Theotokopoulos

John of the Cross

luminescence

mystic

Short Essay

1. Who built the monastery palace of El Escorial? How did it reflect a Renaissance building style?

2. El Escorial had several ties to Italian architects and artists. Who were the principle architects for this structure and what was their relationship to Italian Renaissance architecture?

3. This artist was one of the most famous painters in Spain but was from another country. He studied under Titian in Italy and began his life of art as an Icon painter. What is his name? What other Italian artists' influences show in his work?

4. Did the religious zealots of Spain inspire El Greco? Describe his work, *Burial of Count Orgaz*. How does El Greco depict spatial conventions in this image?

Netherlandish Art

Vocabulary

Protestant
Pieter Brueghel the Elder
Caterina van Hemessen

United Provinces
panoramic

Hieronymus Bosch
cycles

Short Essay

1. What religious controversies resulted in the need for artists to seek out private patrons rather than the church in the Netherlands?

2. What do we know of the works of Caterina van Hemessen?

3. Describe the scene in the painting *The Garden of Earthly Delights* (c. 1505) by Hieronymus Bosch. What do you think the artist intended meaning was for this triptych? Be sure to comment on symbols such as the owl.

4. Why was the elder Brueghel nicknamed "Peasant" Brueghel?

5. Pieter Brueghel the Elder's *Carrying of the Cross* is said to be composed in a way that guides the eye through the painting. Describe how you think that occurs. Where do you enter the painting and how do you move through the work?

6. Where did Brueghel find subjects?

7. Who found Brueghel's work most engaging?

England and the English Court

Vocabulary

Tudor	Henry VIII	Thomas More
King's Paintrix	Levina Bening Teerling	Elizabeth I
Mary Tudor	Philip II	Edward VI
Elizabethan Age	Nicholas Hilliard	Hardwick Hall
Robert Smythson	tilting	

Short Essay

1. Who was Levina Bening Teerling and what position did she hold in the court?

2. King Henry VIII had his portrait painted by Hans Holbein the Younger. The clothing he wore was the fashion of what country?

3. Describe the succession which rose to the throne in England after the death of Henry VIII. Did religion play a role for the winning of the crown and if so how?

4. Describe the advancement of architecture in England. Did Henry VIII play a significant role in this campaign and if so how?

5. How does Hardwick Hall differ from traditional Elizabethan building style?

Chapter 19

Baroque, Rococo, and Early American Art

As we move into the seventeenth century remember Europe is critically divided religiously. The Reformation and the *Protest-ants* are widely spread. The preaching of Martin Luther has become the popular religion of Northern Europe while Roman Catholicism is steadfastly holding on as the major religion of Italy, Spain, France and much of Southern Europe. The Vatican centers the major stronghold of Catholicism. The European world is growing complicated. This has a great impact on the art being created. Despite religious divergence the world is entrenched in the ideas of humanism and that leads to a host of artistic predicaments. We will be looking at a variety of contrasts and comparisons between styles of expression and the politics of aristocratic economy. What began as a reaction to the rational Renaissance and developed into an elegant expression of Mannerism in the sixteenth century progresses to a bolder Baroque decorative style and finalizes in the spontaneous imagery of the aristocracy and Rococo. And of course let us not forget those impressionable Americans. Throughout this chapter you should be concentrating on the following ideas:

1. **Are there natural elements present in all of the various Baroque styles?**

2. **What are the differences of specific styles throughout this time period? More importantly what grounds these styles?**

3. **How did architecture in the cultural centers of the world influences architectural development elsewhere?**

4. **How did European conventions and culture influence North American artists?**

The Baroque Period

Vocabulary

Baroque	genre	Counter-Reformation
barroco	rocaille	impasto
naturalistic	verisimilitude	glazes

Short Answer

1. The word baroque has developed several different meanings. Describe the different meanings of the word baroque.

2. Do other forms of art besides visual art use the word baroque such as music or dance? Do some research and contrast and compare the word baroque as referred to a period in art and also a period in music for example.

3. What did scientific understanding reveal about the Earth and the Universe that changed the way Europeans thought about themselves and humanity?

Italy

Vocabulary

Churrigueresque	Counter-Reformation	della Porta
Pedro de Ribera	Gianlorenzo Bernini	Vatican
gable	broken pediment	swags
niches	finial	colosal order
Saint Peter's Basilica	colonnade	baldachine
Francesco Borromini	Carracci Academy	apex
obelisk	giant reliquaries	balustrade
cartouche	cornice	travertine
trompe l'oeil	galleria	allegory
fresco	ignudi	academic
tenebrism	baroque naturalism	French Royal Academy
Farnese Family	Guido Reni	Cortona
Gaulli	Caravaggio	rubenistes
Artemisia Gentileschi	l'Enfant,	Vignola
Carlo Madermo	facade	poussinistes

Short Essay

1. How did the Vatican react to the Reformation movement?

2. What happened to art commissioned by the Roman Catholic Church versus art being made in Northern Europe as a result of the Reformation and iconoclastic movements?

3. What was the Counter-Reformation? Who were the major supporters of this movement?

4. What type of building projects began in Rome as a result of the Counter-Reformation?

5. How did Carlo Maderno's façade for the front of Saint Peter's represent the Counter-Reformation movement?

6. What is a composite order column?

7. Describe the political and religious significance of the baldacchino created by Bernini for Saint Peter's Basilica? Was the baldacchino important to the Counter-Reformation and if so why?

8. Bernini used travertine in the colonnade that surrounds a huge double piazza and two huge curved porticoes of Saint Peter's Basilica. What is this stone? Why did he use it here?

9. What does the colonnade and porticoes represent? What shape is in the center of the colonnade?

10. What two great architects did Francesco Borromini work under?

11. How does the apex of the Church of San Carlo alle Quattro Fontane give the appearance of floating?

12. Borromini abandoned the modular system of architectural planning used since Brunelleschi. What did he substitute it with and how was that received throughout Europe?

13. Bernini first became famous as a sculptor. His impression of David is very different that those of Michelangelo and of Donatello. Go back to Chapters 17 and 18 and contrast and compare all three Davids. Then describe the moment in time that the sculptor chose to depict. How do these moments differ? Do these three separate moments reflect a political or social response as well?

14. Bernini often posed his figures in natural or informal settings. Go to the sculpture of *Saint Teresa of Avila in Ecsta*sy and describe the setting she is being portrayed in? Is this informal or formal, defend your argument?

15. How did Bernini get the commission for the fountain in Rome's Piazza Navona (*Four Rivers Fountain*)?

16. What is the theme of this fountain?

17. The Farnese family in Bologna wanted to redecorate the ceiling in their galleria (great room). What painter was given the commission and how did he incorporate classical mythology into this work?

18. The Farnese ceiling uses a specific painting technique. What is this technique? Was there another painter who inspired the artist by using this technique before, if so who was he and how did he use this technique and in what building did he use it?

19. Who is Michelangelo Merisi? Like many other Italian artists he was known by another name. What was his more familiar name?

20. Define tenebrism. Are there popular art forms today (movies for example) that use these kinds of light sources? Mention a few that may have been influenced by the convention of tenebrism. Does this type of light source have an emotional impact on the viewer, if so why does this occur, if not why not?

21. Who is Artemisia Gentileschi? Describe her influences and content of the majority of her images.

Long Essay

Contrast and compare the Farnese ceiling with the Triumph of the Barberini ceiling fresco in the Gran Salone, Palazzo Baberini, Rome and the Triumph of the Name of Jesus in the vault of the Church of Il Gesu, Rome. Think about content, composition, illusionary techniques and figurative form. Try to find parallels and variations in each. How do these images correspond with the baroque style?

France

Vocabulary

Versailles	Versailles chateaux	Girardon
Claude Lorrain	Poussin	Georges de la Tour
Baroque garden design	parterres	Louis XIV
giuge	sarabande	minuet
Vitruvian Man	Palladio	rustication
Charles Le Brun	Jules Hardouin-Mansart	Palais de Versaille
Caravaggism	chiaroscuro	Nicolas Poussin
Claude Lorrain	Antoine Le Nain	Prix de Rome
Cardinal Richelieu	Maria de Medici	Absolute Monarch
terrain		

Short Essay

1. How long did king Louis XIV rule France? How did his monarchy support the arts and cultural development of France?

2. Who were the designers of king Louis XIV's new and improved Palais de Versailles?

3. Describe the terrain around the Palais de Versailles.

4. What was the *Hall of Mirrors* in the Palais de Versailles used for? Did it aid Louis XIV in developing a vision of absolute monarchy?

5. What historical styles were drawn upon to create the sculpture, *Apollo Attended by the Nymphs of Thetis*? Who was the sculptor? How did work suggest baroque stylization?

6. What is Caravaggism? Is it the same as chiaroscuro? Tenebrism?

7. What is a classical landscape?

8. How were Claude Lorrain and Nicholas Poussin ideas about classicism transcended into teaching practice within the Royal Academy?

9. Contrast and compare *Judith and the Maidservant* by Gentileschi with *Magdalen with the Smoking Flame* by Georges de La Tour.

10. Does Hyacinth Rigaud painting of King Louis XIV reflect classical or Caravaggesque conventions. Why or why not?

Habsburg Germany and Austria

Vocabulary

Jakob Prandtauer westwork Benedictine

Short Essay

1. Briefly describe the religious and political climate of Germany and Austria during the seventeenth and eighteenth centuries.

2. How did German Baroque architects give their buildings a strong vertical emphasis? What is the name of this tradition?

3. What was the function of the Melk monastery? Why was the interior appropriate for this function?

Habsburg Spain

Vocabulary

Francisco de Zurbaran	Cotan	DiegoVelazquez
Churrigueresque	Moorish	Lo Spagnoletto
Spanish Moors	Mercedarians	Juan Sanchez Cotan
spatial ambiguity	matte	underdrawing

Short Essay

1. What is the Spanish Golden Age?

2. The Spanish Empire is in decline in the 1600's. Describe changes that occur in the Spanish Empire in the seventeenth century?

3. Define Churrigueresque style? Where did this style originate and how did it get its name? Give architectural examples in your answer.

4. What was the primary influence on Spanish painting during the fifteenth century?

5. Why does your text define Zubaran's work, *Saint Serapion*, as a tragic still life? What does this mean? Note the background in this painting.

6. What is spatial ambiguity? Describe how this is evident in the work of Juan Sanchez Cotan.

7. How would you define the subject matter in DiegoVelazquez 's *Water Carrier of Seville*? What type of painting does this fall under? What kind of light source is used in this image?

8. Does DiegoVelazquez change his style of painting? If so what do you find different from his earlier work?

9. How does DiegoVelazquez use the layering of paint in *Las Meninas*?

The Southern Netherlands/Flanders

Vocabulary

Peter Paul Rubens	Anthony van Dyck	Antwerp Painters guild
Clara Peeters	pretiola	Maria de Medici
Henry IV	Habsurg	

Short Essay

1. What happened to the capital city of Flanders when its port silted up?

2. Peter Paul Rubens was from what country?

3. How did Rubens come to be considered synonymous with Flemish art?

4. How do the side panels in the *Raising of the Cross* differ from previous triptychs?

5. What are Ruben's unique ideas of thematic and formal unity (Examples could be drawn from compositional elements, lighting and emotional content)?

6. How old was Clara Peeters when her career as a painter began?

7. Describe the content in Clara Peeters painting.

The Northern Netherlands/United Dutch Republic

Vocabulary

Frans Hals	Judith Leyster	Utrecht
Rembrandt van Rijn	etching	drypoint
Printmaking	Aelbert Cuyp	Jacob van Ruisdael
Meindert Hobbema	Gerard Ter Borch	Jan Vermeer
de Witte	burin	genre
motif	school	architectural interior
still life	flower pieces	Willem Kalf
Ann Maria Sibylla Merian	Rachel Ruysch	

Short Essay - Portraiture

1. Who was William of Orange and what was his patronage of the arts?

2. Describe the range of Dutch art.

3. How did Dutch portrait artists idealize their subjects?

4. What was group portraiture and how did the Dutch stylize it?

5. Describe the expressions of the subjects painted in Frans Hals' *Catharina Hooft and Her Nurse*.

6. Who is Judith Leyster and what was her relationship to Frans Hals?

7. How does Judith Leyster make a visual pun between herself and the image she is portraying herself to be painting in her self portrait?

8. He painted mythological paintings, landscapes and figure studies but his primary mode of painting was portraiture. He is considered one of the most important painters of seventeenth century Amsterdam. Who is he?

9. Describe why the *Night Watch* is now called *Captain Frans Banning Cocq Mustering His Company*.

Long Essay- Portraiture

1. Describe the changes between the first and third engraving states of Rembrandt van Rijn's *Three Crosses* (fig. 19-55 and 19-56) c.1663. How does this painting reflect some of Rembrandt's own thinking regarding spirituality and religion?

2. Contrast and compare *The Jewish Bride* by Rembrandt van Rijn with Jan van Eyck's *Portrait of Giovanni Arnolfini (?) and His Wife, Giovanna Cenami (?)* (fig. 17-14, p. 633).

Short Essay - Landscape

1. Describe the different types of Dutch landscaping painting.

2. How does van Ruisdael's *The Jewish Cemetery* create a mood?

3. Was there a Dutch seascape painting tradition and if so what was it?

4. How did Aelbert Cuyp rework the Dutch seascape tradition?

Long Essay- Landscape

1. How did the various Dutch landscape painters reflect morality, spirituality and religious conviction in their work?

Short Essay – Genre Painting

1. Dutch genre paintings were categorized in their own times by the following titles: "merry company." "garden party," and "picture with little figures." These titles seem innocent enough but what did these categories actually mean?

2. Do you think that Gerard Ter Borch is describing a friendly visit or something else in the *Suitor's Visit* (fig. 19-65)?

3. This artist frequently painted enigmatic scenes of women in their homes, alone or with a servant, who are occupied with some cultivated activity, such as writing, reading letters or playing a musical instrument. Who is this artist? Describe how this artist uses light and compositional elements.

4. Does Vermeer use vanitas themes in his work and if so how?

5. What type of genre painting is considered an architectural interior? Give examples of a painter who uses this technique.

Short Essay – Still Lifes

1. What is the Dutch word for still life painting?

2. Does the Still Life style suggest scientific observation and if so how?

3. Name the important Still Life Dutch artists of this period.

England

Vocabulary

Inigo Jones	Christopher Wren	pilasters
Bays	balustrade	oculus
Pavilion	lantern	John Vanbruch

Short Essay

1. What classical elements did Inigo Jones use in the façade on the Banqueting Hall for the Palace of Whitehall (fig. 19-68)?

2. Who decorated the ceiling of the Banquet Hall for the Palace of Whitehall (fig. 19-69)?

3. In 1666 a fire demolished most of central London. What architect was continuously involved in the rebuilding projects? What was his major project?

4. Compare and contrast Christopher Wren's style of architecture with John Vanbrugh.

English Colonies in North America

Vocabulary
limner
half timber construction
wattle and daub
clapboard
Parson Capen House

Short Essay

1. What contributed to the spread of European art in the American Colonies in the seventeenth and eighteenth centuries?

2. What was the plentiful building material in North America? How did this contribute to the building style?

3. What changes were made from the European building styles to the North American building style that provided the homes with a more comfortable and weatherproof space?

4. Painting in the Colonies was used to keep what type of records?

Chapter 20

Art of India after 1100

The ancient cultures sustained art from the three principle creeds of India, Buddhism, Hinduism and Jainism. Invaders from the northwest introduced another religious culture, that of Islam. India now becomes more complex with the mélange of beliefs and traditions when the three original belief systems are permeated by the addition of Islam. After you have finished this chapter in your workbook, you should have a clear understanding of the following concepts. Read these questions now and think about them throughout your work then respond to them at the end of the chapter.

1. **What are the recognized major chronological periods of early and modern India?**

2. **How does Islamic tradition adjust to the powerful legacy of India?**

Late Medieval Period

Terminology

Buddhism	Hinduism	Jainism
Bodhisattvas	tantric	Buddha
Islam	Mahavira	tirthankaras
Kalpa Sutra	Sanskrit	gopura
vimana	Shiva	

Short Essay

1. How did Buddhism change in the Medieval period?

2. What is the main goal of Buddhism?

3. How can you tell the difference between a bodhisattva and a Buddha?

4. Who is the most sacred of the bodhisattva? Why?

5. Who is the last of the twenty-four saviors in the Jainism?

6. Why did the various religions of India practice more private forms of artistic expression during the medieval period? What were these more private forms?

7. What religion was the dominant religion of India during the Early Medieval period?

8. How did Islamic rule in the north change the pattern of temple building for the various religions of India?

9. How did the Vijayanagar kinds and their successors the Nayaks influence monumental building efforts of the Hindu?

Long Essay

1. Describe the southern temple style of the seventh century and how it evolves into the style of the Minakshi-Sundareshvara Temple (fig. 20-4)?

Mughal Period

Terminology

Mosques	Mughals	Hamza-nama
cenotaphs	Taj Mahal	Gita Govinda
Krishna	mausoleum	minaret
chamfered	finial	iwan
Rajput painting	chattri	

Short Essay

1. Who was Babur and how did he influence the history of India?

2. What Mughal king had the most power over the positioning of the Mughal empire and the establishment of Mughal art?

3. Who was Hamza? How was his story preserved in the Mughal empire?

4. Indian architecture had been primarily post and lintel construction until the Islamic architects introduced what elements?

5. Why was the Taj Mahal built?

6. Describe the meaning behind the *Gita Govinda*. Who produced this manuscript?

Modern Period

1. Describe the content of the *Hour of Cowdust* (fig.20-9).

2. How did the British empire change the architecture of India?

3. How did Pierre Jeanneret influence architecture in modern India?

Chapter 21

Chinese Art after 1280

China is a country that has experienced a great deal of change throughout its history. We will concentrate on the three dynasties of China Yuan, Ming and the Qing dynasties and how these three dynasties influenced art. China has a long tradition of scholarly pursuits. Yet during times of unrest and Mongolian leadership its scholars were not honored. This changed the course of Chinese art, poetry and literature. You will investigate the art throughout this time in China and then take a quick look at the modern period. In this chapter you should be concentrating on the following ideas:

1. **What are the main historical divisions of China since the late thirteenth century?**

2. **What are the differences between official court art, and the art created for scholars and intellectuals friends?**

3. **What kind of art is created during times of war in China?**

Yuan Dynasty

Vocabulary

Mongolian	Jenghiz Khan	Kublai Khan
barbarian	Yuan	calligraphy
Marco Polo	literati	colophon panel
handscroll	hanging scroll	album leaf

Short Essay

1. Who was Jenghiz Khan? What tribe did he lead and how did he influence the Chinese imperial power structure?

2. Who was Kublai Khan and how did influence Chinese art?

3. How were the intellectuals viewed by the Yuan dynasty?

4. What medium did the literati choose to express themselves?

45

5. What was the status of the calligrapher in Chinese society?

6. What was the status of the painter in Chinese society?

7. What is the difference between the literati and professional painters?

8. Who did the literati paint images for?

9. *Autumn colors on the Qiao* (fig. 21-2) was painted by a "literati" who later was accepted by the Yuan dynasty. Who was this painter and how does this image reflect the views of the literati?

10. Describe the different variations of scrolls.

11. What is an album leaf?

12. How does one read a handscroll?

Ming Dynasty

Vocabulary

Civil service exams	Qui Ying	porcelain
underglaze	kilns	glazing
the Forbidden City	mortise and tenon	geomancy
cosmology	feng shui	Meridian Gate
Kaolin	petuntse	feldspar

Short Essay

1. How did the Ming dynasty come into existence?

2. Describe the difference between court painting and the painting of the literati.

3. What style does Yin Hong emulate in the *Hundreds of Birds Admiring the Peacocks*, (fig. 21-4)?

4. What is the symbolism in the above work?

5. What is porcelain? How is it made?

6. What was the most renowned center for porcelain in China during the Ming dynasty? Why?

7. How is the armchair in fig. 21-7 constructed?

8. What is geomancy?

9. What is cosmology?

10. What is qi?

11. How did geomancy, cosmology and qi influence Chinese architecture?

12. Where is the Forbidden City? What emperor built it?

13. Describe the ancient Chinese symbolism in the Forbidden City.

14. Describe the difference between the northern school of art and the southern school of art.

15. Dong Qichang's "Read ten thousand books and walk ten thousand miles" discusses his views on art. How did he describe excellence in a painting?

Qing Dynasty

Terminology

Manchu orthodox individualists

Short Essay

Who are the Manchu?

How did the Manchu view Chinese customs and painting traditions?

How did the Manchu view the literati?

Who were the individualists?

Describe the work of Shitao. How does your text describe his work?

Modern Period

Terminology

Imperial rule communist Wu Guanzhong
Western influence

Short Essay

How did communism change the art of China?

Has Western influence changed Chinese art? Why?

Chapter 22

Japanese Art after 1392

Japanese art places a great deal of significance in the natural world and over centuries have developed a sensitivity to the materials of nature. To understand the art of this period you must develop a sense of the Japanese aesthetic. It is a clear understanding of light, color, space, materials, asymmetry, and clean lines. . By the time you finish this chapter in the workbook, you should have a clear understanding of the following concepts and be able to answer these questions with ease.

1. How is Zen Buddhism as a major artistic force in Japanese art?

2. What is the Japanese compassion for nature founded on?

3. How do the Japanese think about asymmetry as a compositional structure?

4. How do contradiction and humor play a role in Japanese art?

Muromachi Period

Terminology

Shinto	Zen Buddhism	shogun
Samurai	Pure Land Buddhism	ink painting
Shubun		

Short Essay

1. Who was the first great master of Muromachi ink painting? How do we know his work? How did the work of his students reflect the move of Zen Buddhism as the new dominant cultural force in Japan during this time?

2. What was the primary duty of the monks during the Muromachi period?

3. How did Zen artists view landscape painting?

4. What is a monochrome painting?

5. How do you create an ink painting?

6. What is a false Zen?

7. Describe a "dry garden."

Momoyama Period

Terminology

Daimyo	feudal	gold leaf
fusuma	tea ceremony	tatami
tokonoma	shoji	writing alcove
shoin	bay	

Short Essay

1. Who were the Momoyama?

2. How did they view the arts?

3. What was the fatal flaw of samurai government?

4. What was the importance of the Japanese tea ceremony?

5. Describe the basic structure of a Japanese shoin residence.

6. What is secular architecture?

Edo Period

Terminology

Tokugawa	neo-Confucianism	cha no yu
raku	lacquer	Rimpa School
writing box	inlay	maki-e
Nanga School	Maruyama-Shijo School	key block
polychrome	registration marks	ukiyo-e
nishiki-e		

Short Essay

1. Why was the Tokugawa family able to bring peace and prosperity to Japan? What kind of government did they provide?

2. Did the Tokugawa family initiate a class system? What was the hierarchy and did this change over time?

3. What did they replace Zen Buddhism with?

4. How did the tea ceremony bring cooperation to the different classes of Japanese people?

5. Was the Rimpa School a formal school system? What kinds of design came out of the Rimpa School?

6. Who were some of the main artists in the Rimpa School?

7. What is lacquerware? How is it made?

8. What is a writing box?

9. What was the spiritual context of the Nanga School?

10. What is the symbolism in Uragami Gyokudo's work *Geese Aslant in the High Wind* (fig. 22-12)?

11. What happened to Zen during the Edo period?

12. Hakuin Ekaku had an effect on Zen Buddhism, what was it? What was his favorite subject later in life? How did these images portray strength and force?

13. What kind of work did the Maruyama-Shijo School create? How did it differ from that of the Zen School?

14. Who were the patrons of the Maruyama-Shijo School?

15. Describe the work of Okyo? How does he present humor in his images?

16. Describe the process of Japanese wood prints.

17. How many prints were made of Hiroshige and Hokusai's prints (fig. 22-1)? How was this done?

Meiji and Modern Period

Terminology

Eastern Capital industrialization abstract

Short Essay

1. How did globalization change the culture of Japan?

2. Is the Western influence seen in Japanese modern art? How?

Long Essay

Japanese art has traditionally combined both Chinese and Japanese art in earlier periods. Now the combination is one of both Western and Japanese styles. Describe how this is evident in the ceramic examples in fig. 22-16.

Chapter 23

Art of the Americas after 1300

People with a long and rich history of tradition and culture inhabited the Americas when the Europeans first arrived here. In this chapter you will look at the art of the Americas from the Northwestern and Eastern Coastlines of North America, Mexico and South America. While reading this chapter in your text you will want to consider an investigation of the circumstances in which the objects of art were made. When you have finished your reading and completed this chapter in your workbook, you should have a clear understanding of the following concepts. Read these questions now and think about them throughout your work then respond to them at the end of the chapter

1. **What is the geography of the Western Hemisphere?**

2. **What historical events happened in the Western Hemisphere that changed the lives of the people who inhabited these areas?**

3. **What are the differences of the two great peoples of South America the Aztec and the Inka?**

4. **What were the common materials used in the making of art objects in both North and South America?**

5. **How did Europeans influence and change the art of both the North and South American regions?**

6. **What are the differences in art produced in the many regions of North America?**

Mexico and South America

Terminology

Aztec	Inka	Tenochtitlan
Hernan Cortes	Huitzilopochtli	Coatlicue
Codex Mendoza	bloodletting	Cuzco
Land of the Four Quarters	puma	beveled
atrial crosses	cherub	tolteca

Short Essay

1. Where does the name Aztec derive from? What did the Aztec actually call themselves?

2. Describe the Aztec class system.

3. Why did the Aztec partake in the practice of bloodletting and human sacrifice?

4. What is the *Codex Mendoza*?

5. What was the great Pyramid used for?

6. Describe the image of the Moon Goddess in fig. 23-3.

7. What did the Inka call their empire?

8. The Inka Empire was a diverse group of people. How did its rulers hold the empire together?

9. The Inka built a great many roads. How did this aid their empire?

10. How did the Inka keep detailed accounts?

11. What about the construction of Inka masonry helped it to survive earthquakes?

12. Describe the Inka use of textiles?

13. What types of symbolism was used in Inka textiles?

14. What were the Spanish who conquered the Inka most interested in?

North America

Terminology

Quillwork	beadwork	reintegration
Blackfoot	tepees	Hamatsa
Tlingit	Haida	Kwakiutl
coiling	twining	plaiting
warp	Pueblos	Anasazi
Hohokam	Navajo	birch bark
Iroquois	wampum	Chief
Shaman	Pomo	

Short Essay

1. Describe how the North American people of the Eastern Woodlands survived.

2. How did they get along with Europeans who settled there?

3. What role did the Iroquois play in the American Revolution?

4. Describe the process of quillwork.

5. How did the Sioux view quillwork? Describe associated symbolism in the quillwork babycarrier in fig. 23-10.

6. How did the Delaware and Iroquois use wampum?

7. What is the process of reintegration?

8. How did the nomadic Plains people describe themselves?

9. Who was responsible for work on buffalo hides?

10. Elaborate on the scene from the buffalo hide in fig. 23-13.

11. How were tepees often decorated?

12. What type of family groups did Northwest Coastal people live in? How did this influence the types of dwellings they lived in?

13. What distinguished the Chiefs from the shamans in the Northwest Coastal people?

14. How were the dead chiefs honored?

15. Describe the dance to the Hamatsu. What is the symbolism in this ritual?

16. What was the screen in fig. 23-14 most likely used for?

17. What lost art did Canadian Haida artist Bill Reid revitalize?

18. What is coiling?

19. What type of material was used in the coiled Pomo basket shown in the grey box on Basketry Technique? What was it used for? Why are there few of these baskets left?

20. Who were the Anasazi? What type of architecture did they construct?

21. What is blackware pottery?

22. Who is Dorothy Dunn? Describe the "Indian" style that she encouraged.

23. Describe the story of Spider Woman in Navajo mythology.

24. What is Navajo sand painting? Who is allowed to do this type of ritual painting?

25. Who is Hosteen Klah and how did he break with Navajo tradition?

Contemporary Native American Art

Terminology

Salish	Shoshone	Cree
canoe	tomahawks	headdress

Short Essay

How are Native American contemporary artists seeking to break with traditional art?

Long Essay

What images in Jaune Quick-to-see Smith's work (fig. 23-23) remind us of the trinkets that were once traded for land by the Europeans? How does this work reflect a political disposition?

Chapter 24

Art of Pacific Cultures

The lands of the Pacific support a variety of thickly descriptive cultures, a wealth of ecological systems, and populations with deep convictions and intricate spiritual beliefs that compose a precious and imaginative existence. Your text examines the extremely serious treatment the Pacific cultures place on the power of art and on the power of life. Your text comments on the power of nature linked with ancestral lineage as a constant theme that permeates art and culture of this area. Read these questions now and think about them throughout your work then respond to them at the end of the chapter.

1. **What are the four main cultures of the Pacific? Locate them geographically.**

2. **What are the main materials used in Pacific art work? How do they vary between cultures?**

3. **What is meant by serious art? Are all art products meant for preservation?**

4. **How do the different cultures reflect ancestral heritage and nature within their subject matter?**

The Peopling of the Pacific

Short Essay

1. What are the four main geographical areas of the Pacific?

2. What are the meanings behind the various names of the pacific cultures?

3. Who were the Lapita people? What were they famous for?

Australia

Terminology

Aboriginal	x-ray style	cross-hatching
Dream Time	monsoon season	Mimis

Short Essay

1. Who were the Aborigines? How did they survive?

2. What is a mimis?

3. What is the relationship between mimis and the x-ray style of the aborigines?

4. Do we completely understand Aboriginal origin myths through their paintings? Why or why not?

Melanesia

Terminology

Lapita	slip	incised
figurative	tamberan	Abelam
mbis	malanggan	tatanua

Short Essay

1. Who performed most of the rituals of the Lapita peoples?

2. What is the largest island in Melanesia?

3. How is wealth measured among the Abelam?

4. How was the tamberan house constructed? What symbolism is attached to it?

5. Describe the Asmat ancestral spirit poles in fig. 24-6 and be sure to incorporate the symbolism in your description.

6. What is a malanggan ceremony? Are preparations for this ceremony hidden from any particular group and if so who?

7. What is a tatanua mask?

Micronesia

Terminology

Nan Madol	basalt	courses
stretcher	header	

Short Essay

What was the *Nan Madol* (fig. 24-8 built for?

Polynesia

Terminology

Tahiti	ahu	moai
Marquesas	Hawaii	Captain James Cook
tapa	chevron	appliqué
kahili	Endeavor	King Kamehameha II
marae	Maori	bargeboards
gable	hei-tiki	tattoo
moko		

Short Essay

1. Why were Polnesian art objects more permanent then those of Melanesia?

2. What is a marae?

3. What is a moai? What was the purpose of these stone figures? How many are there?

4. Why did Easter Islanders stop erecting maoi?

5. How did warriors from the Marquesas dress? Why?

6. What were feather cloaks worn for?

7. Who was Captain James Cook? What was the name of his ship? Who was Sydney Parkinson and what was his purpose on Captain Cook's voyage?

8. What is a hei-tiki?

9. What is a moko?

10. Who were the Maori?

11. What are the Maori especially known for?

12. What is a Maori meetinghouse? What did their structures symbolize? How did the different architectural elements reflect this symbolism?

13. How were women accepted within the confines of the meetinghouse?

Recent Art in Oceania

1. Contemporary artists in Oceania have practiced what anthropologists call reintegration. What does this mean?

2. How are quilts used in reintegration?

3. How are Hawaiian symbols combined with Christianity in Deborah U. Kakalia's quilt, *Royal Symbols* (fig. 24-14)?

Chapter 25

Art of Africa in the Modern Era

The art of Africa is a fundamental and integral element for the many distinct African groups of peoples. The diversity is overwhelming. More than 1,000 languages have already been found on this continent. Your text explores the large continent of Africa through common community events such as the raising of children, rites of initiation into adulthood, leadership, and death rather than in a less descriptive chronological or geographical way. Art in a context of social, political, and religious purposes is supported by individual communities and is considered of the utmost importance in those communities. Yet this art is not limited to the past but alive and vibrant in the present. You will investigate the art throughout this time in Africa and then take a quick look at the modern period. In this chapter you should be concentrating on the following ideas:

1. **How does art reflect ancestry? Does art reflect community growth and devoted connections from generation to generation?**

2. **Does art serve as a traditional element for transporting the children of the community into adulthood?**

3. **How does art communicate to the unknown world of spirit?**

4. **Does art help to establish and maintain order in society?**

Traditional and Contemporary Africa

Terminology

okyeame	Sahara	terra-cotta
Nok	Abidjan	Kinshasa
Dakar	Timbuktu	Ghana
Mali	Songhay	Mopti

Short Essay

1. How did the conquest of North Africa by Arab factions change African culture?

2. Describe trade in ancient Africa as evidenced in the gray box *Foundations of African Cultures*.

3. Describe European contact with the continent of Africa and how that contact changed after the cessation of slave trading.

4. Describe the changes which occurred after World War I in Africa.

Children and the Continuity of Life

Terminology

biiga ere ibeji Mossi
Yoruba

Short Essay

1. What do children represent in traditional African society?

2. What is a biiga?

3. How did the biiga play a part for a female child's growth and spiritual well being? What happens to the biiga as the child matures?

4. What is an ere ibeji? Describe rituals that are attached to this image (fig. 25-3).

5. How does the mother care for the birth of the ere ibeji?

6. What do these images represent overall in African cultures?

Initiation

Terminology

Bwa	Nowo	Mende
Sierra Leone	Sande	bwami
yananio	Lega	kaolin

Short Essay

1. In Western cultures we have initiation rites. What are some of the numerous rites prevalent in Western culture?

2. Initiation into adulthood in many cultures usually happens at the onset of puberty. In the Bwa people the rites to adulthood are symbolic. What are the rites of initiation practiced by the Bwa people and what do they symbolize?

3. Who is the spirit of Do? How did the Bwa communicate with this spirit? Why was this necessary? (See fig. 25-4).

4. Describe the different types of Bwa masks.

5. What does the Nowo mask in fig. 25-5 represent?

6. What type of initiation rituals does the Mende people use?

7. Promotion has another form of ritual in some cultures. Describe the bwami promotion rituals. Use the mask in fig. 25-6 in your description.

The Spirit World

Terminology

thila	boteba	nkisi nkonde
Kongo	savanna	bilongo
blolo bla	Baule	Eshu
blolo bian	pakalala	baaku
Lobi	zoser	orisha

Short Essay

1. How do traditional African societies find answers to difficult and troubling questions? Who do they seek to aid them in this task? Is this kind of seeking limited to African cultures?

2. What is a thila?

3. How do the Lobi people consider themselves a community?

4. What are zoser?

5. How does a boteba represent a thil?

6. What is the expression of the boteba in fig. 25-7?

7. How does the bilongo transform a nkonde?

8. How does a nkonde become a nkisi nkonde?

9. Does one artist create the nkisi nkonde?

10. What is a blolo bla, or a blolo bian? How do Baule people use these carvings?

11. Are major African deities a common theme for sculpture? Why or why not?

12. Who is Olodumare?

Long Essay

Who is the deity Eshu? Is Eshu male or female? Where are the statues of Eshu normally placed? Why?

Leadership

Terminology

Ashanti	kente	warp
weft	oyokoman ogya da mu	
ndop	Kuba	ibol
Anang Ibibio	Ekpo	

Multiple Choice

kente
oyokoman ogya da mu
ndop
ibol

1. The Kuba kings were immortalized by a sculpture called a _____.

1. This woven cloth began with a warp pattern that alternates red, green, and yellow. The pattern is as _____ and means "there is a fire between two factions of the Oyoko clan."

2. The _____ refers to a skill for which the king was noted or an important event that took lace during his lifetime.

3. The Ashanti people are known for the beauty of their woven textiles called _____.

Short Essay

1. Works of art throughout the world identify leaders. Describe how a leader of the Ashanti people uses the staff in fig. 25-1.

2. What materials were used in the making of kente? Are these the same materials that are used today? If not what is different?

3. How was the image of the Kuba king used before and after his death?

4. What is an Ekpo mask? What is it used for?

Death and Ancestors

Terminology

Dogon dama Mali
nlo byeri kanaga duen fobara

Short Essay

1. What is the traditional African view of death?

2. What ritual is associated with the ritual of death? How are these two rituals similar how are they different?

3. What is the ceremony of the forbidden or dangerous? What is the Dogon name for this ritual?

4. How does the ritual of the forbidden or dangerous change according to gender?

5. What is a nsekh o byeri? What does it contain?

6. What relationship does the sculpture in fig. 25-16 have with the nsekh o byeri? Why is the sculpture symmetrical?

7. What is a duen fobara? How is it used?

8. How is the identity of the deceased often communicated in Africa?

Contemporary Art

Terminology

Guro Quattara Magdalene Oduno

1. How are the traditional cultures and artifacts of many African societies viewed today? Are they still in use? If so give an example of this.

2. Have adaptations been made to traditional art forms and if so name a few?

3. What type of schooling did artists like Ouattara receive? How has this influenced his artwork?

4. How does the painting in fig. 25-19 reflect traditional African spirituality?

5. Describe the women's role in the pottery villages? What is the economic situation in these villages?

6. What is most enduring about the African traditional artwork?

Chapter 26

Eighteenth Century Art in Europe and North America

What begins as a semi feudal existence in the West turns into a political, theoretical and industrial revolution in both Europe and the United States. As your text explains, "The developments in politics and economics were themselves manifestations of a larger, single revolution in human thought..." The Enlightenment, critical thought, the early development of present scientific inquiry and the industrialization of common processes changed the way people interpreted their worlds. After you have finished this chapter in your workbook, you should have a clear understanding of the following concepts. Read these questions now and think about them throughout your work then respond to them at the end of the chapter.

1. **What is the Enlightenment and does this theory apply to the world that I live in now?**

2. **What are the tenets of Neoclassicism and Romanticism and are they similar?**

3. **Think about terminology and how we define styles. Are these definitions clear and precise or are these styles becoming more difficult to define?**

The Enlightenment and its Revolutions

Terminology

semifeudal	aristocracy	industrialism
Enlightenment	Reformation	monolithic
John Locke	Voltaire	David Hume
Jean Jacques Rousseau	Denis Diderot	Thomas Jefferson
Benjamin Franklin	Immanuel Kant	Reign of Terror
Revolution	didactic	history paintings
Neo	Napoleon	Grand Manner
genre		

Short Essay

1. How was wealth divided in Europe at the beginning of the eighteenth century?

2. How did the division of wealth change by the end of the eighteenth century?

3. What was the new math and science? Who were its inventors?

4. How did the Reformation thinkers contribute to the Enlightenment?

5. Why was history painting one of the chief vehicles for the Enlightenment?

Long Essay

1. What is the great divide represented by the period of the Enlightenment?

2. How was the Enlightenment symbolic of the theories started in the Renaissance?

The Rococo Style in Europe

Terminology

Jean Antoine Watteau	Germain Boffrand	rococo
Francois Boucher	Jean Honore Fragonard	enamel
hotels	arabesques	S-shapes
C-shapes	volutes	boiseries
Johann Balthasar Neumann	Clodion	roccaille
fete-galante	cabinet piece	momento mori
pastel	porcelain	chinoiseries
tea caddies		

Short Essay

1. Rococo is often seen as a reaction at all levels of society. To what is this style reacting?

2. What is a boiserie?

3. Pictorial themes were often painted or sculpted in rococo residential settings. What was the main narrative taken from classical stories?

4. What is elegant outdoor painting? Find examples from your text.

5. What marketing idea helped the career of the art dealer Edme-Francois Gersaint?

6. What is pastel chalk? Why did it suit the style of the rococo?

7. What is memento mori?

8. Who provided patronage for Francois Boucher?

9. How did Boucher depict China in *La Foire Chinoise* (fig. 26-14)?

Long Essay

1. Bavarian churches often used the rococo styling for interior decoration. Compare and contrast the *Angel Kneeling in Adoration* by Egid Quirin Asam (fig.26-8) with Gianlorenzo Bernini's *Saint Teresa of Avila in Ecstasy* (fig. 19-9, p. 767).

Revivals and Romanticism in Britain

Terminology

moral genre painting	censorship	William Hogarth
Silvertongue	Encyclopedie	Salon
drame bourgeois	melodrama	middle class
Royal Academy	Grand Manner	contrapposto
pose	vistas	Thomas Gainsborough
dauphin	Constitution	Emile ou traite de l'education
citizen	Du contrat social	bust

Short Essay

1. What kind of painting reflects social lessons?

2. How did art of the Enlightenment reflect the treatment of women and children?

3. What was the *Marriage Contract* about (fig. 26-32)?

4. What writer believed it was arts proper function to "inspire virtue and manners?"

5. What was the new theatrical form melodrama all about?

6. Describe the Grand Manner.

7. How does Thomas Gainsborough's portrait of *Mrs. Richard Brinsley Sheridan* (fig. 26-34) characterize the new values of the Enlightenment?

8. How did Palladio inspire British artists?

9. Contrast and compare Baroque gardens and English landscape gardens.

10. Why is the Circus considered part of Neoclassicism?

11. Who is Josiah Wedgwood?

12. What is jasperware?

13. Describe an English Circus house.

Long Essay

1. What does the term Gothic Revival mean? Be sure to list several works of architecture in your answer.

Art in France

Short Essay

1. Who was Marie Louise Elisabeth Vigee-Lebrun?

2. Who was Adelaide Labile Guiard? How did she change the status of women in the Academy?

3. How were women important contributors of national life in France during the Enlightenment?

4. What building is often called the Paris Pantheon? Who was the architect? What style is this building?

5. Your book refers to the work of Claude-Nicolas Ledoux (fig.26-42) as representative of a utopian Enlightenment. Describe Ledoux's vision and how this would be considered a utopian environment.

Short Essay - Neoclassical and Romantic Painting

1. What was the painting by Jacques-Louis David *Oath of the Horatii* (fig. 26-48) about?

2. Why was the above painting considered important to the French revolution?

3. What positions did David hold with the newly formed French government?

4. What part did Jean-Paul Marat play in the French revolution? How did David memorialize him?

5. Who were David's students?

Art in North America

Short Essay

1. Who was John Smibert? Give examples of his work and his influences.

2. Who is considered to be America's first native born artistic genius?

3. Copley was well liked by his Puritan clientele. What was different about Copley and why was he well liked?

Chapter 27
Nineteenth Century Art in Europe and the United States

Chapter 27 considers the nineteenth century in Europe and America. The early part of the century was heir to the Neoclassicism of the late 18th century. Promoted by the major academies of Europe, Neoclassical attitudes affected many aspects of public and private art. Neoclassicism was challenged by Romanticism, which, in its distrust of rationalism, opened a new spontaneity of individual expression. The social and political contrasts, dramatic political changes, and scientific and technological advances of the mid-19th century gave way to new forms of expression, including photography, which offered new ways of seeing. French Realism offered contrasts to Romanticism, and was in turn challenged by Impressionism, which sought to represent the effects of light, color and atmosphere in the painting of contemporary life. At the end of the 19th century, Post-impressionism, symbolism and Art Nouveau set the stage for the radical movements of early 20th century art. In architecture, new design concepts joined with the use of iron and steel support.

1. How may the concept of "revolution" be applied to the various styles of 19th century art?

2. How does art relate to social change?

3. How did science and technology change the way that Europeans and Americans represent information?

4. How did the invention of photography change our thoughts on representations of reality?

5. How does the relationship between the academy and the artist change?

Neoclassicism and Romanticism

Vocabulary

classicism	bird's-eye view	Grand Tour
landscape painting	picturesque	vedute
capriccio	sarcophagi	memorialized
cameos	elevation	intaglios
Parnassus	landscape architecture	pediments
expatriate	rosettes	spirals
garlands	mythological	folio
idyllic	watercolor	Discourses
voussoirs	odalisque	commission
central plan	sublime	
democracy	turrets	

Short Essay

1. Define Neoclassicism.

2. In what formal and iconographic ways was David's painting exemplary of Neoclassicism?

3. What is positivism? How did this movement contribute to the rise of Romanticism?

4. How may Gericault's work *Raft of the Medusa* (fig. 27-6) be considered a Romantic work?

5. Are their similarities of content between Neoclassicism and Romanticism?

6. Why is the work of Jean-Auguste-Dominque Ingres considered masculine? How did he portray women? Please give examples of his work.

7. What was the narrative for the sculpture by Francois Rude, *Departure of the Volunteers of 1792* (fig.27-13)? Where is this sculpture located?

Long Essay

1. Discuss the political implications in the art of Francisco Goya, Jean-Dominique Ingres, and Theodore Gericault.

Short Essay--Romantic Landscape Painting

1. What did Fuseli say about John Constable's landscapes? Why was that?

2. What did Joseph Turner mean by "the course of Empire?"

3. What is topographic landscape painting?

4. How was the work of Constable and Rousseau the beginnings of a major shift in European Art?

Naturalistic, Romantic, and Neoclassical American Art

Short Essay-- Naturalism, Landscape and Genre Painting

1. Who was John Audubon and what was his subject?

2. Who was Thomas Cole?

3. What is the Hudson River School?

4. Who was the "Yankee Stonecutter?"

Revival Styles in Architecture before 1850

Short Essay

1. What Roman temple design is reflected in the Virginia State Capitol?

2. How did Benjamin Henry Latrobe change the capitals of the columns in the United States Capitol?

3. Who was Karl Friedrich Schinkel? What was his most influential building?

4. What building is the British summation of the Gothic style? Who were the architects that designed it?

Early Photography

Vocabulary

Camera obscura	lithography	intaglio
heliographs	diorama	daguerreotype
calotype	primary colors	complements
hues	value	bitumen
aperture	silver halide crystals	negative image

Short Essay

1. How does the camera obscura work?

2. How Niepce use lithography in developing a photography image? What is the name for this kind of image?

3. Describe how the image *The Artists Studio* in fig. 27-33 was made? What was the name of this technique? Who was the artist who invented this technique?

4. Who is William Fox Talbot? What process did he invent? How did it differ from Daguerre's process?

5. Talbot was distressed by the growing industrialization in Europe. How is this evident in fig. 27-34, *The Open Door*?

6. What principle is photography based on?

7. Who attempted to make photographic equivalents of painting?

8. Julia Margaret Cameron received her first camera when she was forty-nine. What did she primarily take pictures of? Why was this different than other artists?

New Materials and Technology in Architecture at Midcentury

Vocabulary

Positivism historicism cast-iron
Arcade polychromed

Short Essay

1. What is the Crystal Palace (fig. 27-38)? Why was it built? Who built it?

2. What is meant by historicism?

3. What new materials were used in the building of the Brooklyn Bridge (fig. 27-39)? Who invented them? Why were they so important?

4. What do the arches of the Brooklyn Bridge celebrate?

5. How does the Biblioteque Sainte Genevieve of Paris (fig. 27-40) reflect both learning and technology?

French Academic Art and Architecture

Short Essay

1. Who was George-Eugene Haussmann and how did he change the face of Paris?

2. Why were the human forms in Jean-Baptiste Carpeaux's *The Dance* (fig. 27-43) offensive to many Parisians?

3. How does *Nymphs and a Satyr* (fig. 27-44) exemplify the new taste in academic art?

French Naturalism and Realism andTheir Spread

Vocabulary

School	Style	realism
Barbizon School	attributed to	peasant
Souvenir	domain	Comte de Saint-Simon
Aversion	Gleaners	

Short Essay-French Naturalism

1. Who was Jean-Baptiste Corot?

2. What utopian sect did Rosa Bonheur belong to?

3. What types of images did Rosa Bonheur paint? Why?

4. How did Jean-Francois Millet's painting *The Gleaners* (fig. 27-47) represent the fate of humanity?

Short Essay-French Realism

1. What mid nineteenth century French critic stresses the importance of art, which deals with realities of contemporary life?

2. Where did the term "realism" come from as it relates to French art in the mid nineteenth century?

3. Who said he was "...*not only a Socialist but a democrat and a Republican in a word, a supporter of the whole Revolution*?" How did these beliefs change this man's painting?

4. Why did critics say that Gustave Courbet's painting *A Burial at Ornans* (fig.27-48) show disrespect for compositional standards?

5. Honore Daumier often depicted what type of scenes from every day life?

6. How does Daumier depict class distinction in *The Third Class Carriage* (fig.27-49)?

Short Essay – Naturalism and Realism outside France

1. Describe the experiences of Wilhelm Leibl in painting *Three Women in a Village Church* (fig.27-50)? How does this image portray realism and or naturalism?

2. What were the aspirations of the Wanderers in Russia? What artist conveys those objectives?

Late-Nineteenth Century Art In Britain

Vocabulary

Pre-Raphaelites	didactiscism	naturalism
Moral truth	visual accuracy	satirize

Short Essay

1. What is a Pre-Raphaelite?

2. What is the meaning behind) William Holman Hunt's *The Hireling Shepherd* (fig.27-52)?

3. Who was Jane Burden? Name two paintings in which she is immortalized. Who were the artists who created these works?

4. William Morris started a company. What was the name of this company and why did he start it?

5. What movement did William Morris inspire?

6. What is a revival print?

7. Who was one of the first artists to collect prints from Japan? Why was this important in his work?

8. What is Japonisme?

Impressionism

Short Essay

1. What is meant by the phrase "painter of modern life" as explained in your text?

2. Describe how Edouard Manet's painting *Le Dejeuner sur l'Herbe* (fig. 27-56) reflects his relationship with the poet and author Charles Baudelaire.

3. The quote in your book begins, *"When you go out to paint, try to forget what objects you have before you--a tree, a house, a field, or whatever. Merely thin, here is a little square of blue, here an oblong of pink, here a streak of yellow..."* Who said this and how did this differ from the realists painters like Courbet?

4. How does your text describe Claude Monet's mature style?

5. Why did Monet and his friends call themselves a Corporation of Artists (Societe Anonyme)?

6. How did the work of Monet and Pissaro differ when it came to the depiction of landscapes and the use of genre as seen in the previous generations works?

7. Pierre-Auguste Renoir is said in your text to have combined Monet's style in the rendering of natural light with his own taste for the figure. Describe this explanation in the painting *Moulin de la Galette* (fig.27-61).

8. Edgar Degas thought of himself as both a naturalist and a realist. How does the painting *The Rehearsal on Stage* (fig.27-62) represent this?

9. Who was Mary Cassatt? What subject matter did she focus on in her work?

10. Who was Berthe Morisot? How was she different from Edma Morisot?

Long Essay

1. How does *Le Dejeuner sur l'Herbe* (The Luncheon on the Grass) (fig.27-56) reflect the duality of man?

2. How does Manet describe Parisian night life in *A Bar at the Folies-Bergere* (fig 27-65)? Describe the compositional use of mirrors in this image.

Post Impressionism

Terminology

collective aesthetic
chromolithography
patisserie
pasarca maiastra
pointillism

burghers
idealized
sabotier
graphic artist
complementary colors

caricatures
boulangerie
Igor Stravinsky
avant garde
primitive

Fill in the Blank

1. _____ unlike _____, does not refer to a collective style but to a time period.

2. One of the earliest and most famous examples of Expressionism is ____ _____ _____ , which van Gogh painted from the window of his cell in a mental asylum.

3. As an artist Edvard Munch was rejected for his frank treatment of _____ and _____ not only by the general public with no particular interest in art but also by progressive artists and critics-members of the Berlin Secession, who invited him to show his work in 1892, were so shocked by it they closed the exhibition.

4. _____ dedicated himself to portraying a large population of social outcasts who he found in an area of Paris known as Montmarte.

Short Essay

1. Who were the major artists that comprised the Post-Impressionist movement?

2. How did Post-Impressionism differ from Impressionism?

3. Describe Paul Cézanne's study of nature.

4. What is divisionism or pointillism, and who is known for his pointillist paintings?

5. Discuss the symbolism in Vincent van Gogh's Starry Night (fig.28-73).

6. Paul Gauguin considered it the artist's task to paint feelings as well as observation. What does his painting *Mahana no atua* (fig. 27-74) say about his response to Impressionism?

7. The Symbolists opposed the values of rationalism and progress and built on Gauguin's search for mystery.How is this evident in Moreau's *The Apparition* (fig. 27-75)?

8. Describe the ways in which *The Scream* (fig. 27-79) combines Symbolism with Expressionism.

Art Nouveau

1. Where did the Art Nouveau movement come from and why?

2. Who was Gustave Eiffel?

3. Who was Victor Horta? How was he influenced by the Arts and Crafts movement in England?

4. Who was Hector Guimard? Where was his major emphasis?

Art and Architecture in the United States

Terminology

"high art"	concubine	abolitionists
romantic naturalism	lofty emotion	nationalism
American Luminists	metaphorical reading	carnage
Manifest Destiny	new Eden	

Fill in the Blanks

1. American painters and sculptors were slow to assimilate _____ as expressed in European art and architecture.

2. The European academic tradition continued to be a _____ influence in the United States, partly because of the growing interest of American architects who received the conservative training of the Ecole des Beaux-Arts.

3. _____ _____ was America's most popular chronicler of the old west.

4. Another European style that American artists adopted after 1880 was _____.

5. Raised in Philadelphia this African American artist _____ _____ _____ studied under Thomas Eakins at the Pennsylvania Academy of the fine Arts sporadically between 1879 and 1885.

Short Essay – Neoclassical Sculpture

1. How does Harriet Hosmer's sculpture *Zenobia in Chains* (fig.27-85) represent neoclassicism?

2. Who is Edmonia Lewis? How does her work Hagar in the Wilderness (fig. 27-86) represent the plight of her entire race?

Short Essay – Landscape Painting and Photography

1. How is the work of Frederick Edwin Church tempered with a scientific eye?

2. How does the work of Albert Bierstadt in *The Rocky Mountains, Landers Peak* (fig.27-88) imply historical narrative?

3. What was meant by the term "Manifest Destiny" coined in 1845?

4. How did the myth of America as the new Eden assert itself in genre painting?

Short Essay – Civil War Photography and Sculpture

1. How many lives were lost in the Civil War?

2. What was Brady's Photographic Corps? Who started this division?

3. What kind of impression was made on the American public by the work of Brady's Photographic Corps?

4. How does Timothy O'Sullivan's photograph *Ancient ruins in the Canon de Chelley, Arizona* (fig.27-89) represent human insignificance? Was this a pessimistic or optimistic view?

5. How did sculpture attempt to heal the wounds of the Civil War?

Short Essay – Post-Civil War Realism

1. Who was Winslow Homer? Describe one of his works from your text.

2. Describe the impact of *The Gross Clinic* (fig. 27-94). What was Thomas Eakins trying to accomplish?

Short Essay--Urban Photography

1. What is motion photography? Name one of its pioneers.

2. What did Alfred Stieglitz photograph?

Short Essay--Religious Art

1. Where did Albert Pinkham Ryder's influences derive from?

2. The work of Robert Henri, John Sloan, William Glackens, Everett Shinn and George Luks has been grouped under what title?

3. What was the main focus for subject matter in Jacob Riis' photographs? How did these photographs effect social reform?

4. Who was Alfred Stieglitz? How did he view photography as an art form?

5. What was the Armory Show? Why and when was it held?

6. How did the critics view the Armory Show?

7. How did the Armory show influence American artists?

Chapter 28

The Rise of Modernism in Europe and North America

Modernism deals with a series of intellectual explanations, which define social, political and scientific relationships to reality and how those said realities are interpreted. Modernism is not a clear-cut expression in art history or in any other portion of history. The tenets of modernism are still debated today. Misunderstandings of the specific styles of art arise from the intellectual, social and political underpinnings of modernism that are often thought of as controversial by the general public. In this chapter you will look for elements that seem to combine features of the period from 1880 to 1970. This period unfolds with a search by individual artists to generate a sense of intellectual exploration. What does art mean to culture? What is the culture we are in? The period after World War I in Europe finds individual artists paying homage to and others rejecting traditionalism and historicism. In the place of historicism artists are penetrating new and uncharted territory. After you have finished this chapter in your workbook, you should have a clear understanding of the following concepts. Read these questions now and think about them throughout your work then respond to them at the end of the chapter:

1. **Did industrialization have a direct causal relationship with modernism?**

2. **What is meant by the terms formalism and expressionism?**

3. **What roles do Cubism and German Expressionism play in the formation of twentieth-century modernism?**

4. **What are the basic intellectual premises that caused the creation and progress of non-representational art?**

5. **What is the new aesthetic in architecture and does this aesthetic become available to the whole community or is it reserved for the upper class?**

Early Modernist Tendencies in Europe

Terminology

Fauves	primary colors	Die Brucke
African	Oceanic	"primitive"
Materialist	socialist	Der Blau Reiter
Bohemian	Art Nouveau	Secession

Fill in the Blanks

1. The Spanish movement called _____ was an example of the influence of Art Nouveauon architecture. The leading practitioner was _____.

2. Gustav Klimt's painting *The Kiss* (fig. 28-3) was an example of the Vienna movement called _____.

3. In the fall of 1905 a French critic, Louis Vauxcelles, referred to a loosely affiliated group of young artists as _____ (_____ _____), a term that caught the spirit of the work of the leading members.

4. The Fauves consisted of these members _____, _____, and _____.

5. According to the Fauves, the key to France's regeneration was to recover the _____ direct approach to the world.

6. Matisse in his new emphasis said, *"What I dream of is art devoid of _____ or _____ subject matter."*

7. The German counterpart to Fauvism was _____ _____.

8. The die Brucke artists studied African and Oceanic works to make their own _____ sculptures.

9. Using a stark graphic style Kathe Kollwitz attempted to win sympathy for _____ _____ and to inspire them and her viewers to action on their behalf.

10. Der Reiter was a popular name for the image of ___ _____, mounted and laying a dragon, that appeared on the Moscow city emblem.

Short Essay

1. Matisse rejected the deliberate disharmonies of his Fauvist approach after 1905. What reason did he give in 1908?

2. Where did the name Die Brucke come from?

3. What was one of the favorite motifs of Die Brucke? How did this motif reflect on their views of women?

4. What were the bohemians attracted to?

5. Who was Kathe Kollwitz?

6. How does Kollwitz describe the life of the peasant in her work *The Outbreak* (fig. 28-10)?

7. What did Der Blaue Reiter stand for? Who were the major artists of the movement?

8. Kandinsky not expect his viewers to understand his symbolism in *Improvisation No. 30*. (fig. 28-13. How did he intend to influence them?

Cubism

Vocabulary

cubism

collage

linear elements

analytical cubism

form

synthetic cubism

flatten

Fill in the Blanks

1. Cubism was the joint invention of two men, _____ and
 _____.

2. Picasso's Iberian period culminated in 1907 in the painting ____ _____
 _____.

3. Braque's interest in _____ form and _____ space, kindled by Cezanne,
 was sharpened Picasso's *Demoiselles*.

4. Inspired by Cezanne's example Braque had reduced nature's many colors to its essential _____ and _____.

5. Braque's and Picasso's paintings of 1909 and 1910 initiated what is known as _____ _____ because of the way the artist took objects like the violin in *Violin and Palette* (fig. 28-24) and broke them down into parts as if to analyze them.

6. A _____ is a work composed of separate elements pasted together.

Short Essay

1. What types of images did Picasso paint during his Blue Period? How does this show his influences from Henri de Toulouse Lautrec?

2. How does Pablo Picasso's Self-Portrait (fig.28-19) reflect his unhappy state of mind?

3. How did the Iberian figures from the fifth and sixth centuries influence Picasso?

4. Did the work of Paul Gauguin influence Picasso? If so how?

5. What potential did George Braque see in *Les Demoiselles d'Avignon* (fig. 28-21) that Picasso probably did not intend?

6. Where did the name cubism come from?

7. Describe how Braque changed form and shape to create the painting *Houses at L'Estaque* (fig.28-23).

8. How did Picasso react t o George Braque's painting *Houses at L'Estaque*?

9. Describe the artistic relationship did George Braque and Pablo Picasso.

10. What is Analytic Cubism?

11. What is collage? What materials were used in its composition?

12. What is synthetic cubism? How does collage fit into this description?

13. What types of newspaper clippings did Braque and Picasso use in their synthetic cubist images? Why was this important?

Responses to Cubism

Short Essay – French Response

1. Who is Robert Delaunay? How did he react to Cubism? Fauvism?

2. What is Orphism?

3. Who was Sonia Delaunay-Terk? Why did she receive less historical attention then her famous husband?

Short Essay – Italian Response

1. What is the Technical Manifesto? Who wrote it?

2. Describe the meaning behind Umberto Boccioni's *Unique Forms of Continuity in Space*(fig.28-32).

Short Essay – Russian Response

1. What was the Golden Fleece?

2. Who was Vladimir Tatlin?

3. How did Kazimir Malevich go beyond Cubism? Futurism?

4. What was Suprematism?

Early Modern Architecture

Terminology

historicism	eclecticism	girders
metal beams	Chicago School	

Short Essay

1. What building of Antonio Gaudi has no straight lines? Why did he design it this way?

2. What building elements made the American skyscraper possible?

3. What was the Chicago School of architecture?

4. How did Louis Sullivan bring nature back into the city?

5. Who was Frank Lloyd Wright?

6. Describe how Wright fulfilled his theory that architecture should be in nature not on it, in the Robie House (fig. 28-39).

Modernism in Europe between the Wars

Vocabulary

Postwar Classicism	Utilitarianism	Constructivism
photomontages	Dutch Rationalism	de Stijl
Bauhaus	curtain walls	dada
readymades	assemblage	Surrealism
automatism	Bolsheviks	Prouns

Fill in the Blanks

1. In March 1917 growing Russian dissatisfaction with the war gave revolutionary elements the opportunity to _____ the czarist monarchy.

2. Constructivists were committed to the notion that the artists must _____ the studio to "*go into the factory where the real body of life is made.*"

3. In 1917 Piet Mondrian and Theo van Doesburg started a magazine by the name of _____.

4. The de Stijl movement centered on the belief that instead of living in a state of nature, we could live in an environment designed according to the rules of "_____ _____" and that we too, like our art would be balanced, and our natural instincts purified.

5. The Great War, as World War I was then known, had a _____ effect on Europe's artists and architects.

6. Picasso stayed in Paris, where he faced a growing tide of nationalistic _____ against Cubism.

7. Picasso responded by adopting a _____ style.

Short Essay

1. Why does Picasso revert to a classical style after World War I?

2. Who were the Bolsheviks?

3. What was Lenin's plan for Monumental Propaganda?

4. Who was Aleksandro Rodchenko? What was the Workers Club (fig.28-46) (essentially a reading room) designed for?

5. What is Proun an acronym for ? How did it reflect El Lissitzky's view of Russian man?

6. What is a photomontage? Who used them? What purpose were they used for?

7. What was the de Stijl movement grounded in?

8. How did Piet Mondrian deal with representational elements in his work?

9. Who were the major architect and designer of the de Stijl movement?

Rationalism in the Netherlands

Fill in the Blanks

1. The German counterpart to the de Stijl and Le Corbusier was the _____ which means _____ of _____ and was the brain child of Walter Gropius.

2. Gropius felt that workshop courses in _____, _____, _____, _____, and _____ all of which emphasized the understanding of materials had to be fully mastered before architecture.

3. In the Dessau Bauhaus built in 1925-26 Walter Gropius acknowledges the reinforced _____, _____ and_____ of which it was built; Gropius made no attempt to cover or decorate them.

Short Essay

1. How did the Nazi's receive the German Expressionists and the Bauhaus?

2. Who was Mies van der Rohe? What was his great passion?

Dada

1. Where did the name dada come from?

2. What is a readymade? What was the public view of readymades?

3. What is assemblage?

4. Describe Marcel Duchamp's Fountain (fig. 28-63). How does this challenge our views about art? Do you think there is political commentary in this work?

Surrealism

1. What is meant by paranoic-critical method?

2. What did the Manifesto of Surrealism summarize as its aspirations?

3. Where does the surreal image in *The Persistence of Memory* (fig. 28-67)come from?

4. How does Miro use automatism in his work?

5. What is frottage?

6. Was Picasso a surrealist?

7. Describe the content of Picasso's painting *Guernica* (fig.28-1).

Art and Architecture in the United States Between the Wars

Short Essay

1. How did Georgia O'Keefe's *City Night* (fig. 28-71) reflect her response to an urban setting?

2. Who was Charles Sheeler? How did he view realism? Use his painting *American Landscape* (fig.28-72) in your answer.

3. How did the artists Grant Wood and Thomas Hart Benton feel about urban life in America?

4. How did Edward Hopper represent Urban Realism in his work *Nighthawks* (fig.28-75)?

5. How did the United States Government use art to sell its political programs?

6. Who was Dorothea Lange? Look carefully at the image of the *Migrant Mother* (fig.28-74) does this image bring any painting compositions to mind? If so what type of composition are you reminded of?

7. What was the Harlem Renaissance? What was the emphasis in Aaron Douglass's *Aspects of Negro Life* (fig. 28-77?

8. What is "kinetic" sculpture? Who pioneered mobiles as an art form?

Art in Mexico Between the Wars

Short essay

1. Diego Rivera wants to create art that inspires revolutions. Is this evident in *Man, Controller of the Universe* (fig. 28-84)?

2. How are the uniquely personal works of Frida Kahlo related to Surrealism?

3. Why is *Laughing Mannequins* (fig. 28-86) considered a surrealist image?

Early Modern Art in Canada

Short Essay

1. Explain how *The Jack Pine* (fig. 28-87) may be considered an expression of Canadian national identity.

2. Who was the Group of Seven? How did they influence the work of Emily Carr?

Chapter 29

The International Avant-Garde since 1945

This chapter may seem extremely complicated to you. It is packed with countless names of styles under an endless stream of headings -isms, movements, counter-movements, and non-movements, actions, reactions and counter-actions, post and pre, neo and old. In the contemporary world with our advanced forms of record keeping and our ability to pass on knowledge of all kinds, all of these movements have come to co-exist in our lives. This may seem like a contradiction.

What we know as art in this century is still firmly rooted in historical standards that you have read about in earlier periods. We are still toying with the elements and principles of art and design in formalism and expressionism. Yet art is not limited to the past but alive and vibrant in the present. You will investigate the art up to the present. In this chapter you should be concentrating on the following ideas

1. **How quickly does art change in our time.**

2. **What is the major cultural center of art in the world?**

3. **How has art become a global proposition?**

4. **Does art imitate life or does art imitate art?**

5. **How is art reflected in social change and freedom from oppression?**

The Mainstream Crosses the Atlantic

Short Essay

1. What is meant by the mainstream?

2. How do the mainstream and the avant garde differ?

3. Is the mainstream a concept still valid in your life? Why or why not?

Post War European Art

1. What is existentialism according to Jean Paul Sarte?

2. How were Alberto Giocometti's sculptures the antithesis of the classical ideal?

3. Name some of Francis Bacon's influences. Are they evident in his work? How?

4. What was art brut?

5. How did Debuffet's work include graffiti?

6. What is formless art?

Abstract Expressionism

Short Essay

1. What is abstract expressionism? How was it influenced by Cubism and Surrealism?

2. Did World War II influence the art world? How? Where was this most evident?

3. Who was Arshile Gorky? How did he bring the two influences of Cubism and Surrealism together? Describe how this happens in Gorky's work *Garden in Sochi* (fig.29-7).

4. What is the New York School?

5. Describe how his therapist interpreted *Male and Female* (fig.29-8) by Jackson Pollock.

6. What is gesturalism?

7. Where did Jackson Pollock usually paint? Why?

8. Describe Willem de Kooning's series of women. Where did he find his subjects?

9. Rothko focuses on desolately alienated subjects in his painting (fig. 29-13). How does he depict them?

10. Who is Louise Nevelson? Does her work fit into the definition of assemblage?

11. Helen Frankenthaler worked on the floor just as Pollock did but her technique was different. Describe her technique.

Alternatives to Abstract Expressionism

1. Describe the work of George Segal. Is his work a reaction to Abstract Expressionism? Why or Why not?

2. What is a happening?

3. Who held these happenings?

4. What is performance art?

5. What is fluxism?

6. How did the public respond to Tinguely's assemblage happening *Homage to New York* (fig. 29-22)?

7. Describe how *Canyon* (fig. 29-23) by Robert Rauschenberg was made? What are some of the elements used in this work? What do you think they mean?

8. What does the work by Jasper Johns, *Target with Four Faces* (fig.29-24) convey? What did the art critics think of this work?

9. What is encaustic?

10. American Pop art is often said to be satirical. What do you think? How did the artists use materials of everyday life to make political commentary? Be sure to use examples from your text in your answer.

11. What did the art critics think of Pop art?

12. Who are the major patrons of the arts in this century in Europe and America? How has this changed the way art is made and who makes it?

13. What is post-painterly abstraction? Name two artists who fit into this category. Why do they fit? Describe their styles.

14. What is the relationship between minimalism and post-minimalism? How did Post-minimalism give rise to conceptual art?

15. What was the main emphasis of post-war photographers? How did Minor White hold himself aloof from that emphasis?

From Modernism to Post Modernism

1. What is Post-Modernism?

2. How does postmodernism differ from modernism? Is modernism included in postmodernism? What about other styles of art, are they also included in postmodernism?

Short Essay--Architecture

3. Describe the International style in architecture. Name several architects who worked in this style. Why was the International style considered suitable for humanity?

4. What is meant by vernacular sources?

5. What buildings does the Vanna Venturi house (fig. 29-48) make reference to?

6. Why did Philip Johnson design the AT&T building (fig. 29-50) to look like a piece of furniture? What type of furniture was it supposed to look like?

7. Describe how the Pompidou Centre(fig.29-52) utilizes color to identify structures.

8. The new Guggenheim Museum in Bilbao by Frank Gehry (fig. 29-55) was called the greatest building of our century by Philip Johnson. Describe why this building is so different.

Earthworks and Site-Specific Sculpture

Fill in the Blanks

1. As post-conceptualism was emerging, a number of sculptors, responding to the New York art scene in general and to the Minimalist retreat from the world in particular, sought to take art back to _____.

2. These artists pioneered a new category of art making, called ____-_____ _____, works designed for a particular location, usually out of doors.

3. Michael Heizer, who actually liked to gamble, meant to establish a sharp contrast between the _____ _____ of Las Vegas and the _____ _____ of nature in his work *Double Negative* (fig.29-56).

4. In 1968, Christo and Jeanne-Claude _____ the Kunsthalle, a museum in Berne, Switzerland, and in 1969 one million square feet of the Australian coastline.

Short Essay

1. What is post-conceptualism?

2. What was Michael Heizer disgusted by? How did this influence his direction in art?

116

3. Describe the work of Robert Smithson in *Spiral Jetty* (fig. 29-57). Does this work seem like a reaction to industrialization? If so how, if not why not?

4. What types of mundane subjects did Duane Hanson sculpt?

Feminist Art

Fill in the Blanks

1. The watershed event was the march in 1970 commemorating the fiftieth anniversary of the Nineteenth Amendment to the Constitution, by which women gained the _____.

2. The _____ shape is a symbol for woman and during the French Revolution was an emblem of equality.

3. Feminists were outspoken critics of the increasingly restrictive modernist concept of mainstream art and its virtual _____ of women.

4. Schapiro's mature work _____ is shaped like a house because that was where most women worked and because their domestic art forms were part of a larger concern with the care of others.

5. Many feminists accepted and celebrated the notion that women have a deeper identification with nature than do men, a belief evident in a number of art works from the 1970's including those by Cuban born _____ _____.

Short Essay – Feminist Art

1. What percentage of New York galleries carried women's work in 1970? How many women showed at the Whitney Annual Art exhibit?

2. Who is Alice Neel? How old was she when she had her first one person show?

3. Who is Judy Cohen? Why did she change her name? What type of imagery does she use? Why does she use this imagery?

4. What kinds of materials did Miriam Schapiro work with?

5. Describe the image in Ana Mendieta's untitled work (fig. 29-65) What medium does she use?

Post-Modernism

Vocabulary
pluralism post-modernism neo-expressionist
juxtaposition

Fill in the Blanks

1. Much of the art being made by the end of the 1970's was widely considered to be
_____.

2. A number of critics have resisted using the label postmodern, insisting that
_____ applies to modernism as well and has been a characteristic of art since at least the Post Impressionist era.

3. Those who resist the use of the term postmodern also point to the continued use of the term _____ _____ to describe the most recent developments in art.

Short Essay

1. What is the universal agreement on what the term post-modern means?

2. What is artistic pluralism?

3. Do you think the term avant-garde acts as a proper substitute for the term postmodernism? If so why, if not why not?

Neo-Expressionism

Short Essay

1. Is Neo-Expressionism a male or female phenomenon? What do the critics think?

2. Describe the imagery in Julian Schnabel's *The Death of Fashion* (fig. 29-66). What do you think is the artist's intent? What does he intend for you the viewer to understand from this work?

3. How does Basquiat's work, *Horn Players* (fig. 29-67) reflect his determination to make African-American subject matter visible to a white audience?

4. What images does Anselm Kiefer evoke in his painting *Heath of the Brandenburg March* (fig.29-68). Why is this image so powerful?

Neo-Conceptualism

Fill in the Blanks

1. The analytical and often _____ style emerged in the mid-1980's that seemed to be a reaction to both the emotionalism of Neo-Expressionism and the populism of graffiti art.

2. In *Fire in the Sky* (fig.29-70 Peter Halley applied hyperreal colors to the kind of _____ _____ used in suburban housing.

3. During the late 1970's and 1980's _____ or the representation of a preexisting image as one's own became a popular technique among postmodernists.

Short Essay

1. What is Neo-Conceptualism a reaction to?

2. Describe the meaning associated with Peter Halley's *Fire in the Sky*.(fig. 29-70)

3. Who is Sherrie Levine? How does her work suggest a feminism as a social construction?

4. How does the Jeff Koons sculpture *The New Shelton Wet/Dry Triple Decker* (fig. 29-71) comment on consumerism? Why does it shock his critics?

Short Essay--Later Feminism

1. What is meant by deconstruction in art?

2. Do you think that Cindy Sherman and Barbara Kruger deal with social construction issues? If so how do their images portray this?

Public Art

Short Essay

1. Who is Jenny Holzer? What media does she use for her art? Why is her art postmodern?

2. What types of controversies are prevalent in our times with relationship to art and the public?

3. What materials are used in Video art? How do you know what is video art and what is not?

4. How has the artist's view of the gallery system changed?

5. What kinds of images does David Hammons' use in his sculpture Higher Goals (fig. 29-87). What message is he trying to convey?

6. What is the National Endowment for the Arts? Do you think this is an important government service? How does this agency relate to the governmental art projects you have read about in history?

7. Who is Robert Mappelthorpe? Have you ever heard of him before? What have your heard?

8. Who is Maya Ying Lin? What were some of the problems she solved in her sculpture of the Vietnam Veteran's Memorial (fig. 29-85)? How is this sculpture viewed today? Have you ever visited this sculpture? Would you like to?

9. What do you think is the difference between art and craft? How does the art world view art and craft? Name several artists who have confronted those ideas of separation? Be sure to name their works as well with a brief description of each.

10. What is multiculturalism?

11. Describe the controversy over Chris Ofili's work *The Holy Virgin Mary*. (fox, p. 1175) Do you agree with the Brooklyn Museum or with Mayor Giuliani about the work?

I would like to end this study guide with some words written by the author of your text, Marilyn Stokstad. On page 8 in the front of your text Ms. Stokstad says, *"As each of us develops a genuine appreciation of the arts, we come to see them as the ultimate expression of human faith and integrity as well as creativity. I have tried here to capture that creativity, courage, and vision in such a way as to engage and enrich even those encountering art history for the very first time. If I have done that, I will feel richly rewarded."*

I know that if you have read this far that you have taken this journey in art seriously. I hope that you have found the renewed faith and integrity in life Marilyn Stokstad speaks of. It is here waiting for you.